Lotus

Lotus

PHOTOGRAPHS BY ALLAN BAILLIE

TEXT AND TRANSLATION BY KAZUAKI TANAHASHI

WISDOM PUBLICATIONS • BOSTON

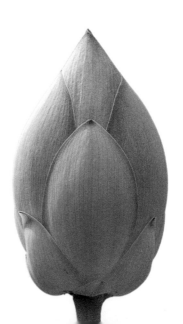

Wisdom Publications
199 Elm Street
Somerville MA 02144 USA
www.wisdompubs.org

Library of Congress Cataloging-in-Publication Data
Tanahashi, Kazuaki, 1933–
 Lotus / Kazuaki Tanahashi, Allan Baillie.
 p. cm.
 ISBN 0-86171-277-3 (pbk. : alk. paper)
 1. Photography of plants. 2. Lotus—Pictorial works. 3. Lotus
in art. 4. Lotus—Poetry. I. Baillie, Allan, 1941– II. Title.
 TR726.L66T36 2006
 779'.343—dc22
 2005029252

ISBN 0-86171-277-3
10 09 08 07 06 5 4 3 2 1

Cover design by TLrggms · Interior design by Gopa & Ted2, Inc. Set in Adobe Garamond 11/15 pt.

Wisdom Publications' books are printed on acid-free paper and meet the guidelines for permanence and durability set by the Council of Library Resources.

Printed in Singapore.

···· *Introduction*

THE LOTUS is a magnificent paradox. Its leaves and flowers grow in the mud and murky water, yet they are unstained. It is associated with both heat and cool, chaos and order, the sun and the moon, even life and death. Under the summer's scorching sun, its blossoms are fragrant on the cool water's surface. Rising above a chaotic array of bright green leaves, the orderly-shaped solitary flowers crown long stalks and dance in the breeze.

The flower is delicate yet vital. The oval-shaped seeds, although tiny, can be fertile for centuries. In 1951, the botanist Ichiro Oga excavated 2,000-year-old lotus seeds from a farm in Hata, Japan. One seed was successfully cultivated and bloomed as the "oldest flower."[1]

In the blossom's center stands a funnel-shaped fruit receptacle topped by a round, flat, perforated seedbed (as can be seen on the cover of this book). When the blossom unfolds, the seedbed exposes its open pods, each containing a seed. The flower's future is already present. Stamens encircle the receptacle, producing nectar that charms insects.

An unfolded lotus, opening at dawn and closing at

sunset, is often poetically compared to the sun; its bud is likened to the moon. Sun and moon, day and night, light and darkness, life and death, death and rebirth: this is the plant's daily cycle. This book, woven with photographs capturing the lotus' celestial beauty, explores the cosmology and poetic imagination invoked by this flower. All scriptural passages and poems in this book are original translations from Chinese and Japanese.

Traditional Chinese poems, including the ones that are collected in this book, often consist of lines of the same length with four, five, or seven ideographs in each line. The relationship among these ideographs is often implied, thus the translated lines tend to be longer than the original.

Since ancient times, the most common Japanese poems have been written in a form called *waka,* which often expresses feelings, and sometimes spiritual teachings as well. In this book some of these poems are presented in a five-line format to reflect the syllabic rhythm of the originals.

Haiku, the other main form of Japanese poems appearing in this book, is a seventeen-syllable poetic form, established by Basho Matsuo (1644–1694). In Japanese, haiku is written in one line in most cases, but it is often translated in three lines. Haiku enables the poet to capture the wonder, joy, and surprise of a moment experienced through observation of a tiny detail of nature. Haiku poems, many of which I've translated for this volume, immortalize the beauty of a scene, just as Allan Baillie's camera crystallizes the marvel of the lotus.

If you'd like to learn more about the lotus, we invite you to look at the appendix on page 95, and if you'd

like to find more about any of the proper names mentioned in the poems, please consult the glossary on page 115.

We hope this book will bring you an illuminating and enjoyable new appreciation of this wonderful flower.

Publisher's Acknowledgment

The publisher gratefully acknowledges the generous help of the Hershey Family Foundation in sponsoring the printing of this book.

Lotus

Emerging from water
a white lotus opens
over the faint
red surface
of the world.

AKIKO YOSANO

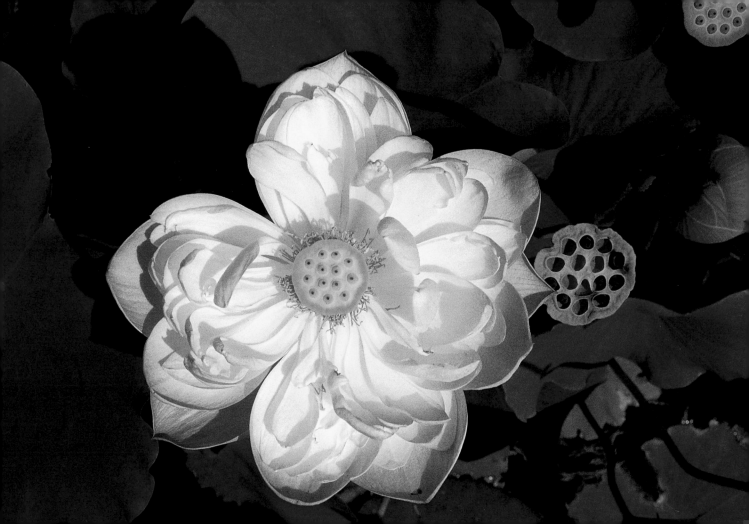

A fragrant lotus levitates
two inches
above water.

BUSON YOSA

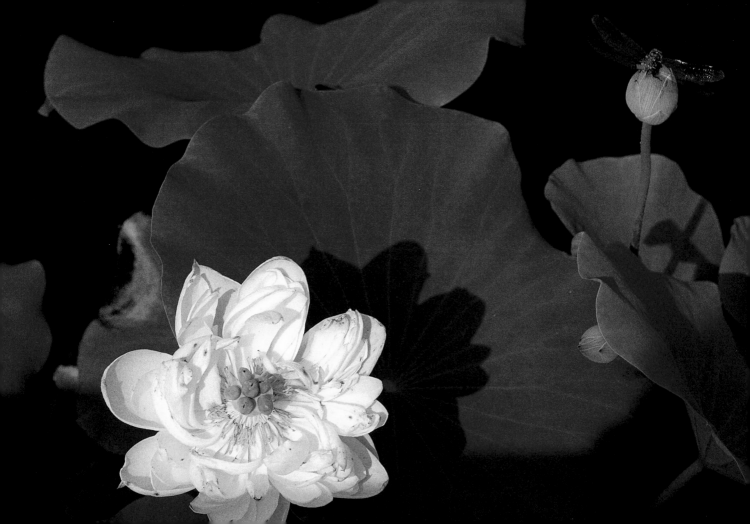

Lotus blossoms
three of them
make the pond crowded.

SHIKI MASAOKA

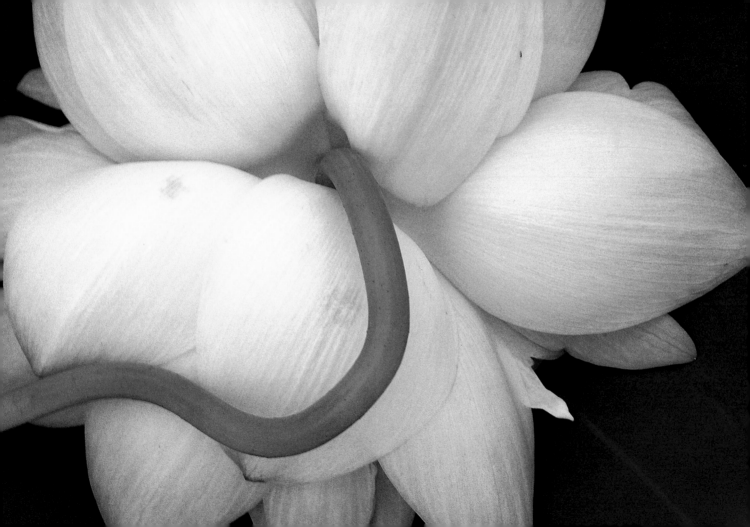

Waves rise
under a floating
lotus leaf.
My heart is moved
to touch you.

TOSHIYORI MINAMOTO

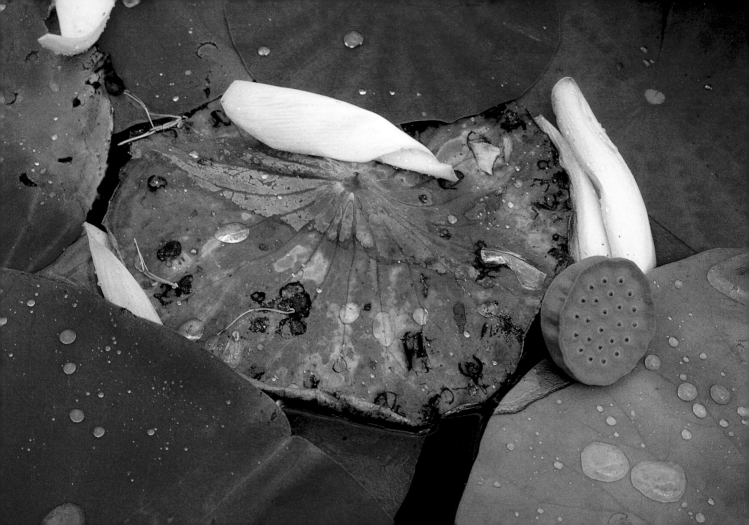

Lotus blossoms
open at dawn.
In the sky,
the moon
sheds its light.

ANONYMOUS (KANKOKU ANTHOLOGY)

When no one is home
to see you,
think of me
looking at the lotus flower
in this little vase.

RYOKAN

I look around: the light on mountains touches the light on water.
I lean on the handrail; the lotus is fragrant for ten miles.
Clear wind and bright moon are beyond human control.
Together they form a whiff of freshness at the South Pavilion.

HUANG TINGJIAN

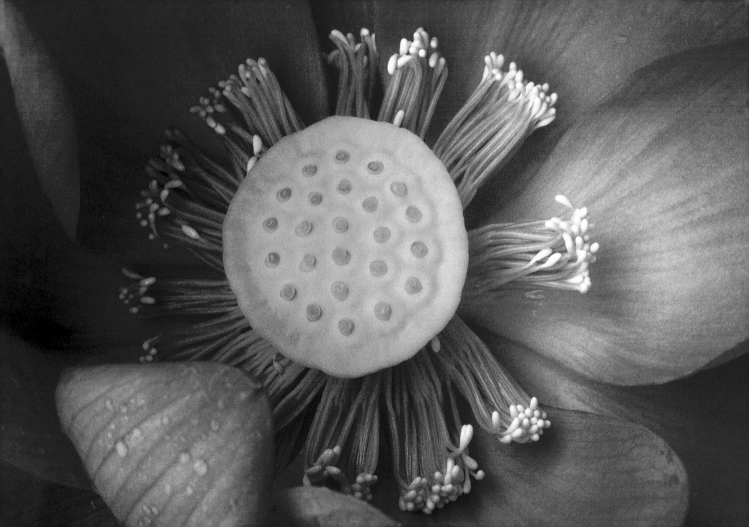

A light boat filled with fine guests
takes a leisurely slide to my house on the lake.
When it arrives, we gather around a kettle of wine.
Lotus blossoms bloom everywhere.

WANG WEI

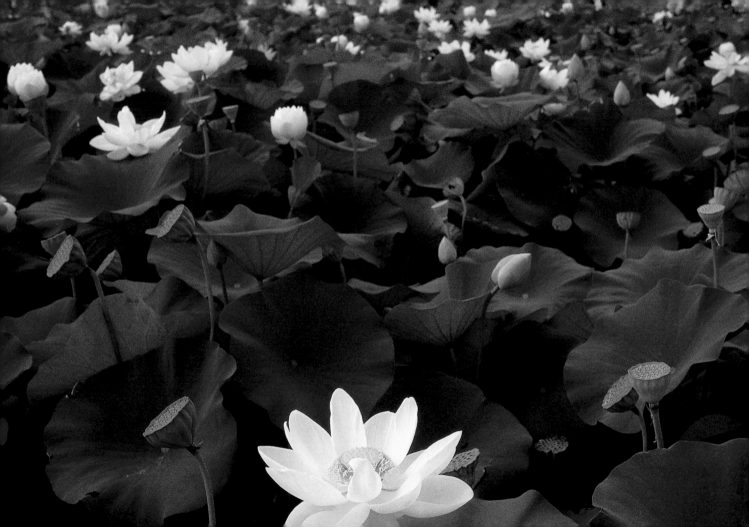

One next to another, the lotus leaves face the morning sun,
their roots lying in the spring water.
Their flatness interrupts the floating weeds;
their frequent wiggling speaks of fish.

SU SHI

Wind over the lotus pond
turns over the leaves
showing their white backs.

BUSON YOSA

Lotus seeds
cross each other
as they pop into the water.

KIJO MURAKAMI

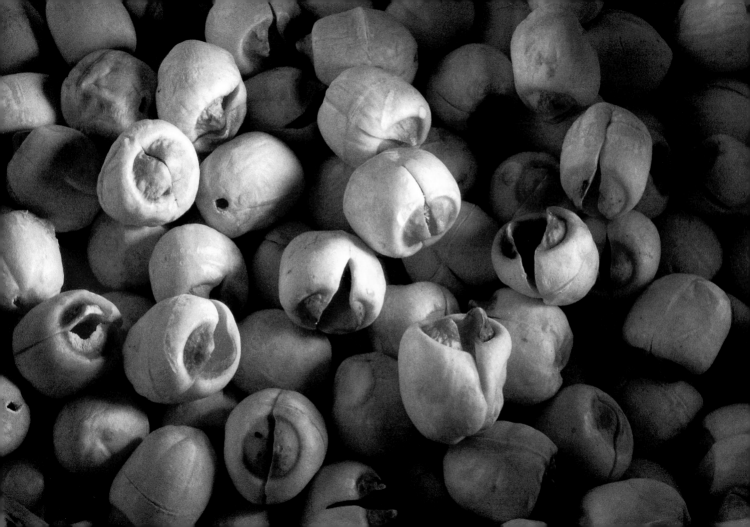

Breaking through the floating leaves,
the lotus-viewers' boat
makes its way.

KITO TAKAI

A fallen petal becomes a boat
gusted to the handle of a lotus parasol.
It stops, floats, floats, and stops.
Its reflection traverses the sky.

YANG WANLI

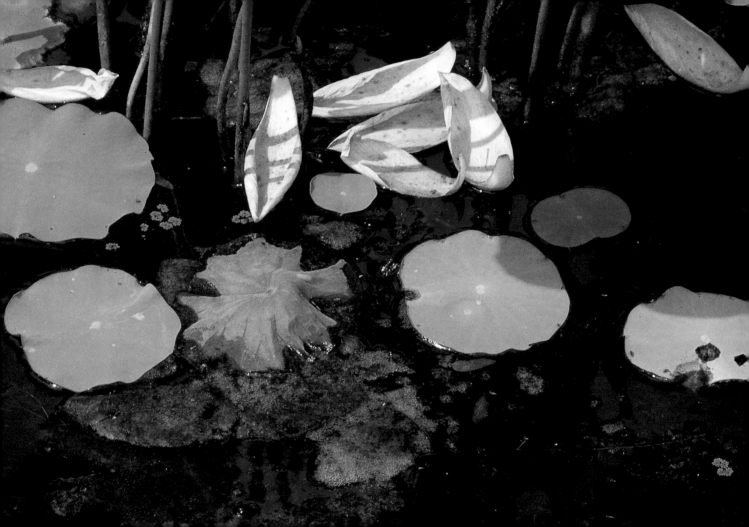

Struck by lotus smell
the noh dancer sees all from
behind his mask's nose.

BASHO MATSUO

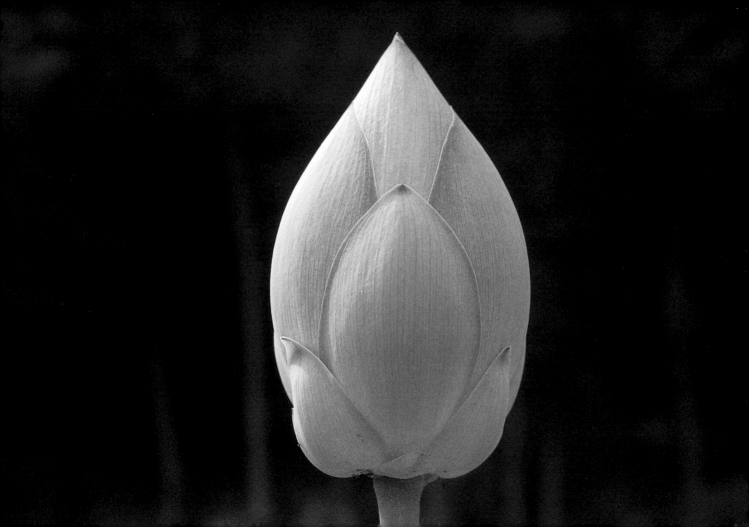

Moon setting—
lotus leaves
unfurl.

GIMEI

Water on the lotus leaf
the sparrows
splashed it away.

ISSA KOBAYASHI

A sorceress in the ripples, still and fragrant,
her complexion pink as if intoxicated.
Lovingly opening in the morning dew;
cold-heartedly closing at the set of the sun,
rooted in mud but unstained snow-white,
sweet-scented in the wind above green leaves—
she reminds me of the beautiful lotus in the Lake Shi,
where a painted boat floats on brocade clouds.

FAN CHENGDAI

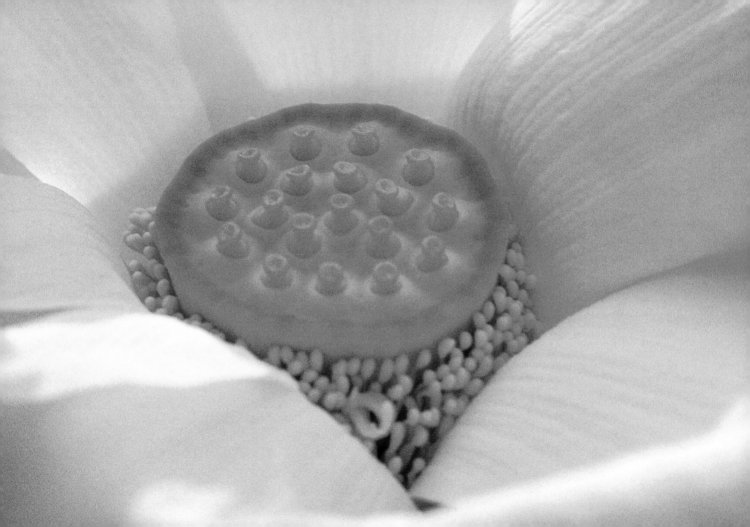

Out of curiosity,
my youthful lips
touch a dewdrop
on the white lotus—
the cold surface shocks me.

AKIKO YOSANO

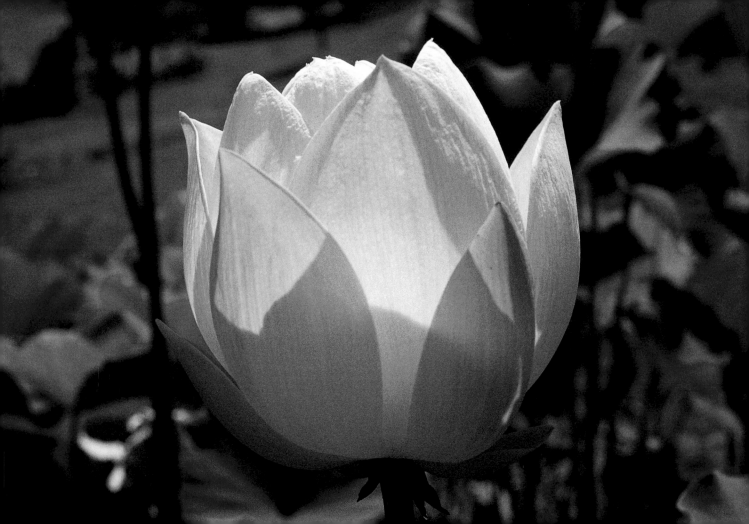

Three hundred miles around Mirror Lake,
the lotus is in full bloom.
Viewers overflow the Ruoye Valley.
The ancient beauty Xisi picks summer flowers.
Not waiting for the moon, she turns her boat,
heading toward King Yue's palace.

LI BO

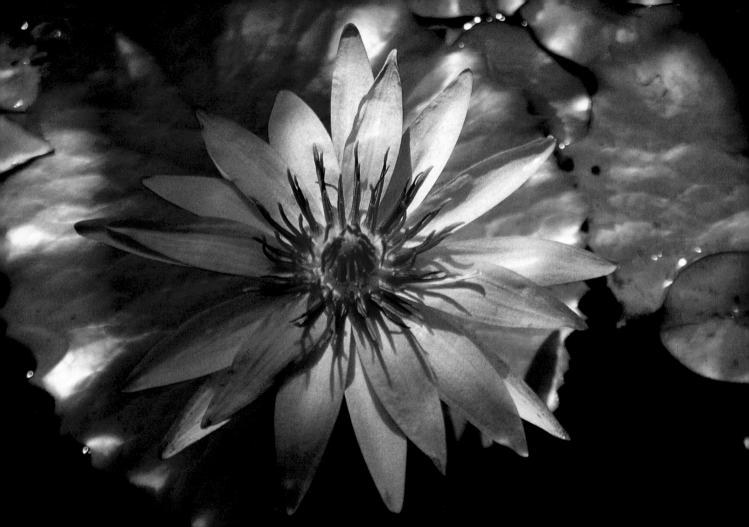

Lotus leaves match the flower-pickers' skirts.
Blossoms open around girls' faces.
Scattered in the pond, none are visible.
Singing announces their presence.

WANG CHANGLING

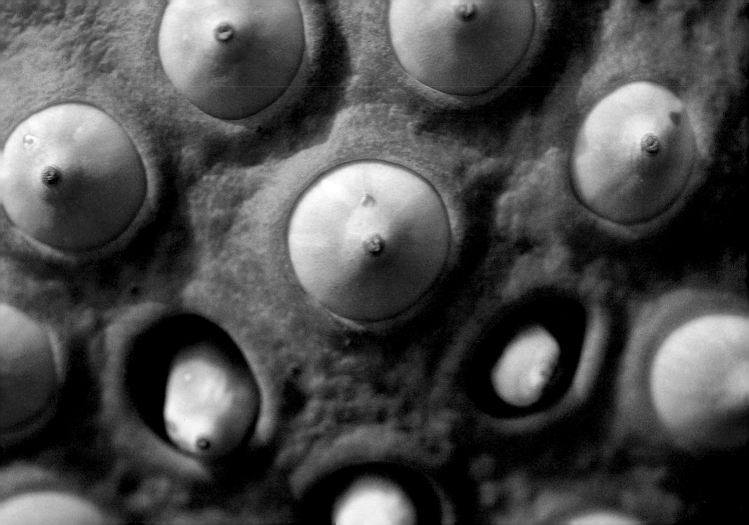

The boat stirs the trembling autumn lake.
A young man skillfully steers past a maiden.
She throws lotus seeds toward him with abandon.
Discovered by another, she hides in embarrassment for hours.

HUANGFU SONG

A young woman rowing a small boat
stealthily picks a white lotus.
The floating weeds leave a clear path,
not knowing how to hide.

BO YUYI

After crossing the river, I pick lotus blossoms.
There are many fragrant stalks in Lan Swamp.
To whom would I want to give these flowers?
My thought is on someone far away.
Looking back, I think of my home town.
The road to it is long and endless.
We share our heart together but live separately.
Sadly we are becoming old.

ANONYMOUS (WENXUAN ANTHOLOGY)

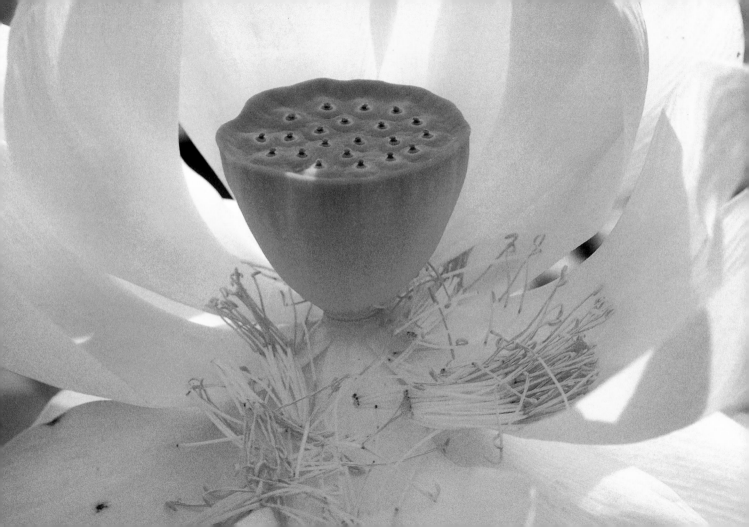

Just as a blue lotus blossom, a red or white lotus blossom, is born and grows in water, but comes out of water and is not attached to water, the Tathagata (the Buddha) is born and grows in the world, comes out of the world, and is not attached to the world.

BUDDHA IN *MAJJHIMA NIKAYA*

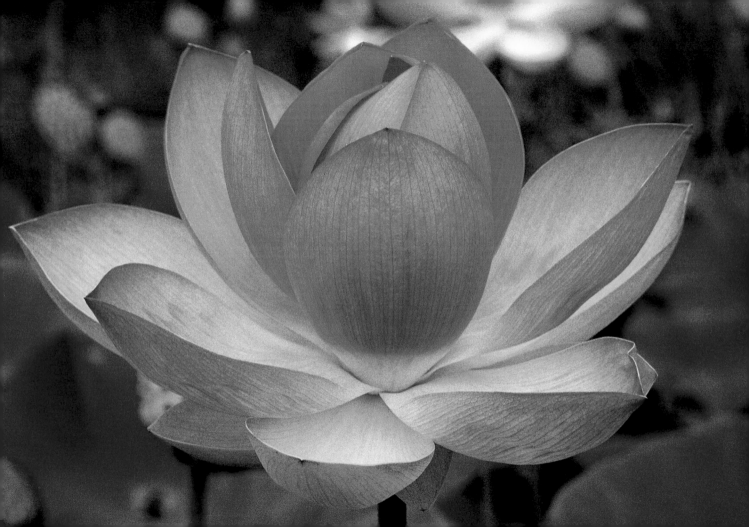

Just as a beautiful fragrant lotus blossom grows from rubbish thrown alongside a road, disciples of the awakened person radiate wisdom among ordinary people.

BUDDHA IN *THE DHAMMAPADA*

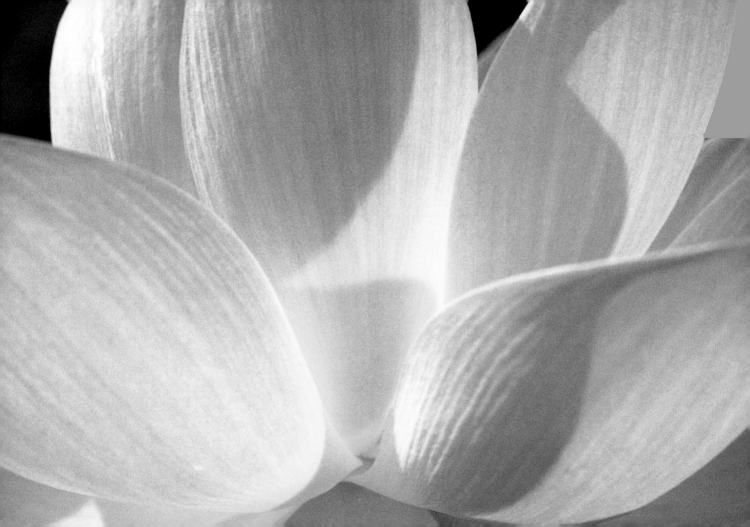

Mount Quanting reminds me of years ago—
when I didn't mind getting drunk with wine.
Now I see these flowers are all like snow.
They match my hair.

WANG YOUCENG

When will the sparrows return to their nest on my beam?
The kitten has left my side,
yet the lotus must love the good old rain:
year after year it opens for me.

WEI YIZUN

Out in the world
the god will play
on the flower pedestal—
unceasing
dharma voice.

ENKU

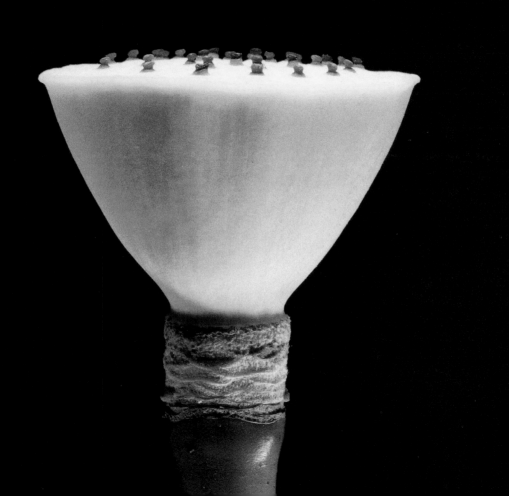

The flames of
the immovable flower
rejoice—
my heart celebrates
for ten thousand generations.

ENKU

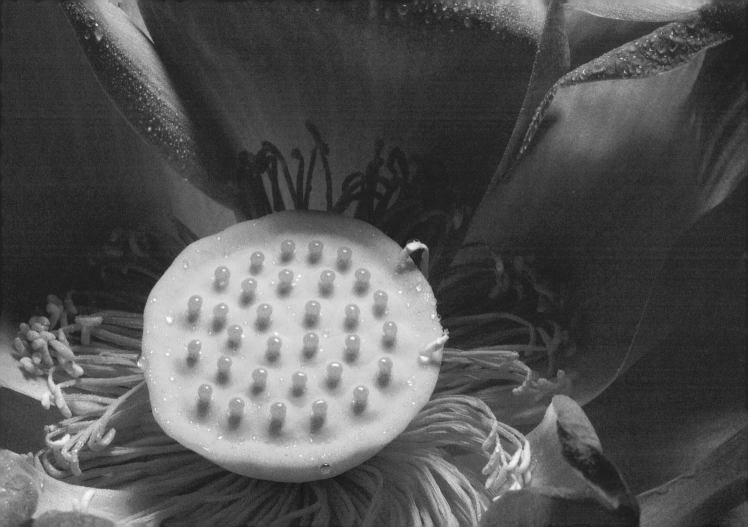

I cultivated depth of mind for one hundred timeless eons. Because of that I became free from being an ordinary person, and attained unsurpassable complete enlightenment. I call myself Vairochana, and reside in the ocean of the lotus blossom pedestal. There are one thousand petals around this pedestal. Each petal is one world, which becomes one thousand worlds. I take the form of a thousand Shakyamunis and am based in the thousand worlds. Then, within the world of one petal there are also one billion Mount Sumerus as well as so many suns and moons, heavens and earths, Jambudvipa Continents, and Bodhisattva Shakyamunis who sit under a billion bodhi trees and expound the bodhisattvas' depth of mind.

INDRA'S NET SUTRA

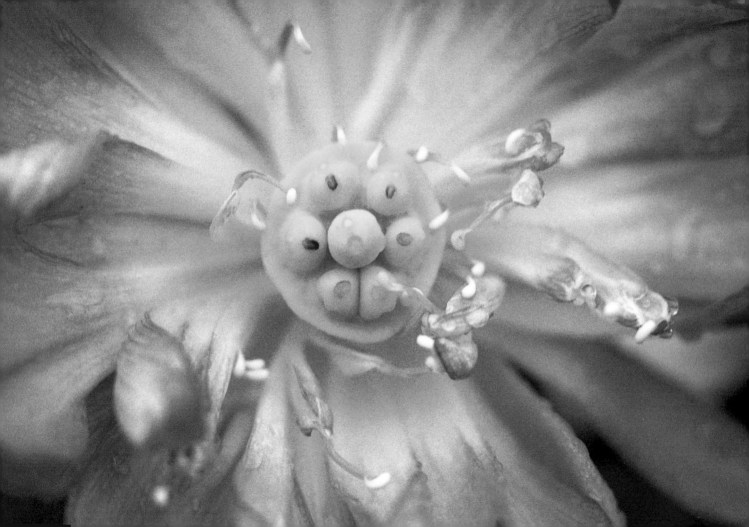

A lotus blossom in the human world is at the most a foot in diameter.
A lotus in Mandakini and Anavatapta ponds are as big as a carriage wheel.
Even larger is a gem lotus in the celestial world upon which to sit in
lotus position. The flower upon which the Buddha is seated excels it
one-hundredfold, one-thousandfold.

TREATISE ON GREAT WISDOM

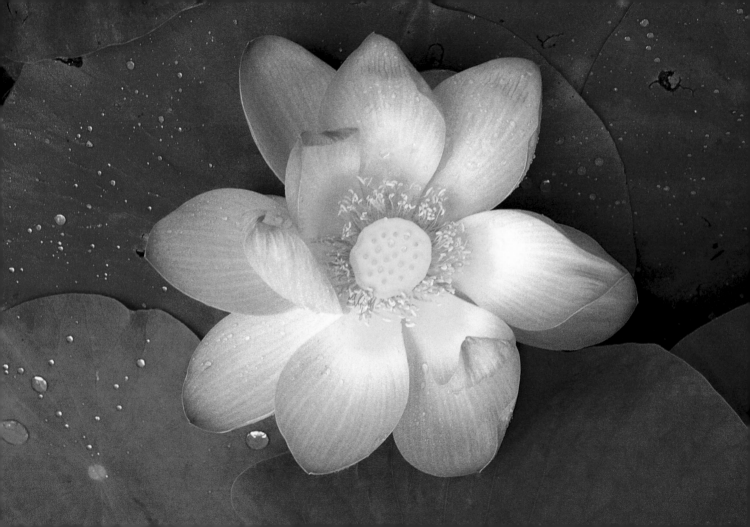

A person with a mean disposition who is bound to be reborn in a low realm is someone who has created unwholesome karma by committing five types of grave violations and ten types of evil deeds. Such a foolish person will fall into unwholesome realms throughout many eons and suffer without end.

When he is about to die, a good teacher consoles him by expounding wondrous dharma and encouraging him to visualize Amitayus Buddha. The fool is in so much pain that he is unable to follow this advice.

The good friend then says, "If you cannot visualize the Buddha, just say his name. Keep saying it with utmost sincerity without stopping. With

full concentration, continue chanting: 'Homage to Amitayus Buddha.' Because of this chanting, moment by moment, sins from eight billion lifetimes are removed. When you end your life, you see a golden lotus flower like the sun appear to you. Then if you keep chanting, you will obtain rebirth in paradise. Avalokiteshvara and Mahasthamaprapta Bodhisattvas will speak to you in greatly compassionate voice. In this phase of reality all your sins will disappear."

Hearing this, this man rejoiced and immediately aroused aspiration for awakening.

SUTRA ON VISUALIZING AMITAYUS

The flower of the Lotus-Womb World signifies reality. Reality is present throughout the phenomenal world and includes all things. Therefore it is called *storehouse*. There is ultimate wondrous bliss in this Lotus Flower Storehouse World. Thus it is called a paradise—a place of extreme bliss.

KUKAI

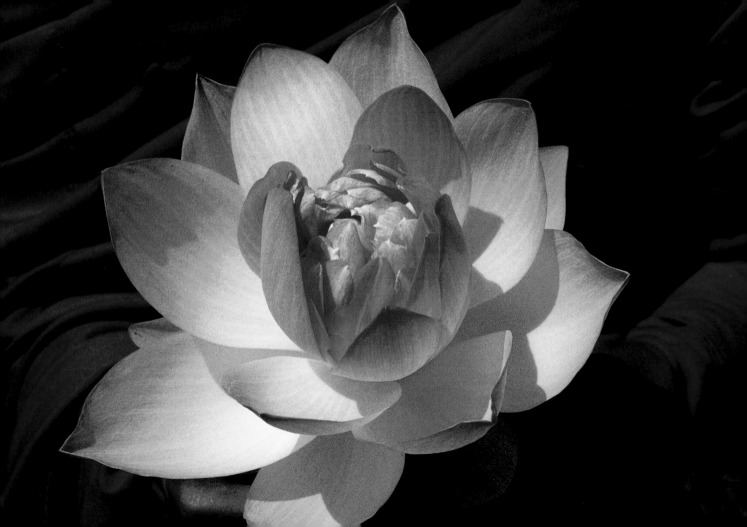

If you want to visualize the Buddha, imagine: There is a lotus blossom
on the earth of seven treasures. Each petal has the colors of one hundred
treasures. Each petal has 84,000 veins, as in a celestial painting.
Each vein radiates 84,000 light beams. Clearly see all of this.
Even a small petal is 250 *yojanas* (travel-day-distances) in length
and width. There are 84,000 of them in each lotus blossom.
Between each petal there is a decoration of a billion gems. Each gem
radiates a thousand beams of light.

SUTRA ON VISUALIZING AMITAYUS

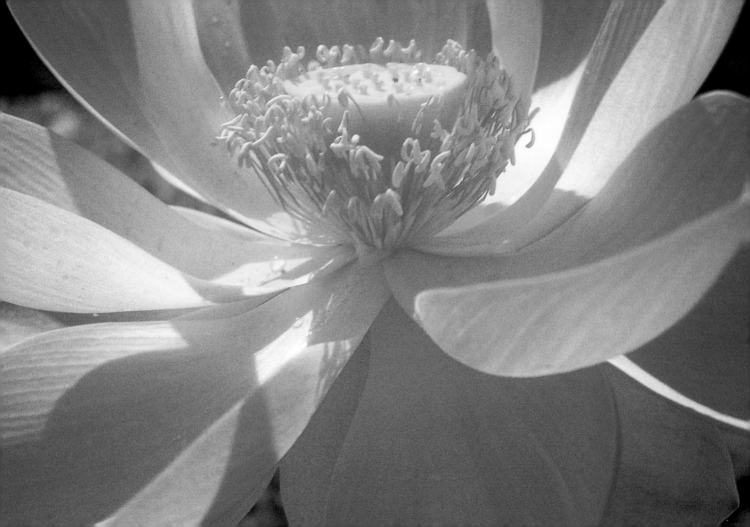

When I see the pond
where the lotus is blooming
I harbor faith in
a dewdrop on the petal
even in this muddy world.

SHOTETSU

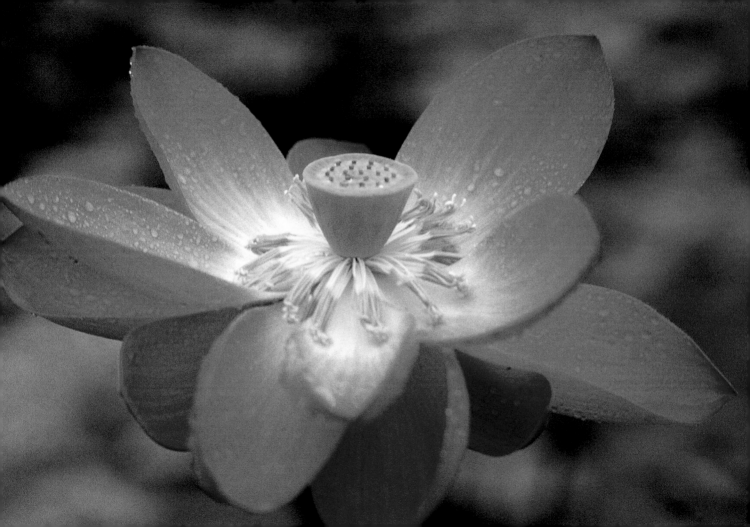

With your heart as pure
as a lotus leaf,
how can you
deceitfully call a dewdrop
a jewel?

HENJO

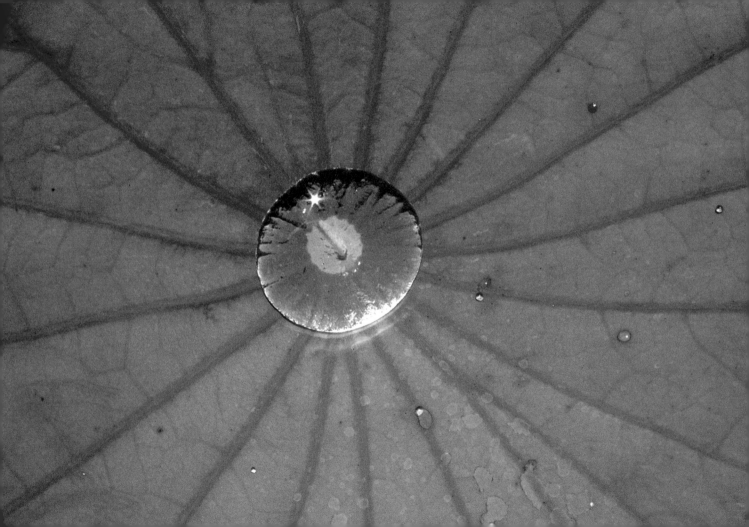

Anyone who chants
"Homage to Amitabha Buddha"
even once
will never fail to
ascend to a lotus leaf.

KUYA

A dewdrop
on the lotus
in paradise—
I would hope for my soul
to be that jewel.

SHIGEKATA FUJIWARA

The lotus is auspicious, excelling myriad flowers. I wish to offer its blossoms, which are compared to the Sutra of Wondrous Dharma Lotus Flower, to the Buddha, pierce its seeds to make beads, and recite the Buddha's name for creating conditions to be born in paradise.

SEI-SHONAGON

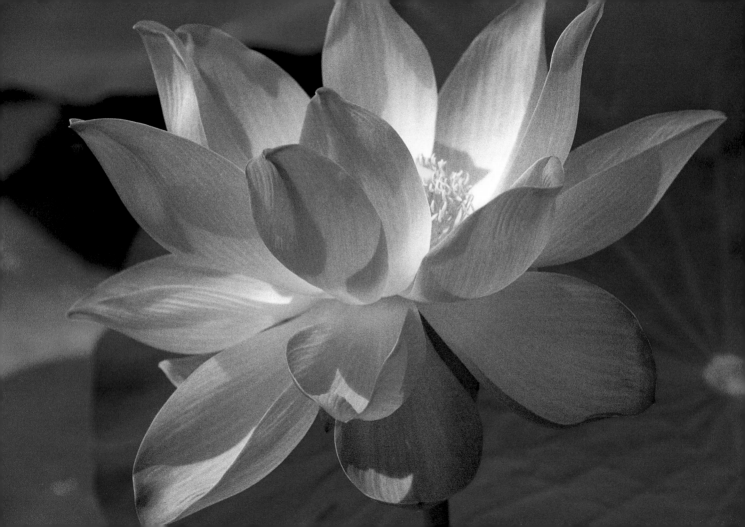

Flowers as they are
in the lotus pond:
My offering to the spirits.

BASHO MATSUO

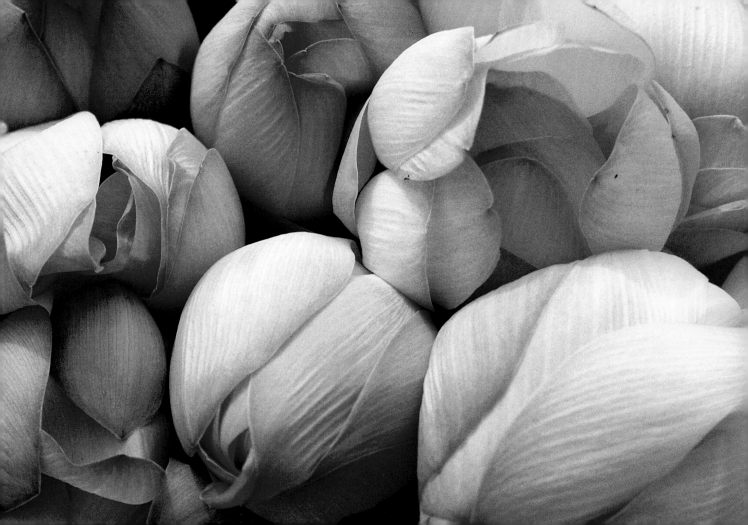

Dark water
silent pond.
Bright jewels flicker
around the lotus leaves—
fireflies.

FORMER EMPEROR JUNTOKU

I see now
that this dewdrop life
is not regrettable,
as it's destined to be
a pearl on the lotus.

SANEKATA FUJIWARA

Even if I know
I will turn into a pearl
on the lotus leaf,
I still wet my sleeves with tears
like morning dew.

MICHITSUNA FUJIWARA'S MOTHER

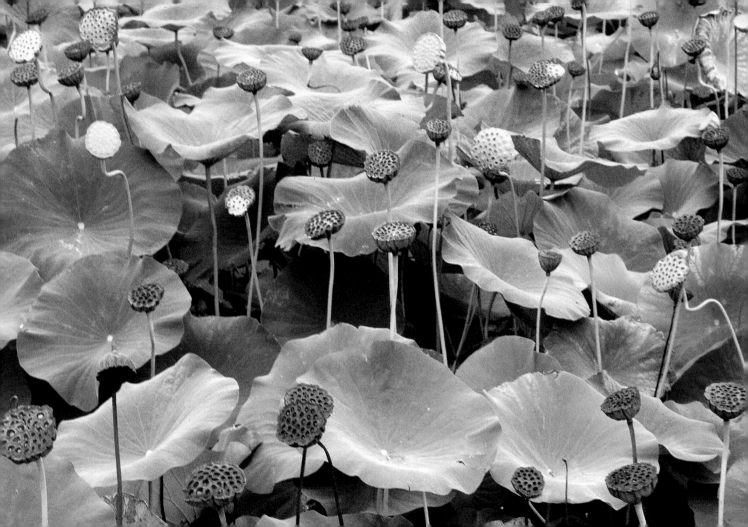

The spirit of my lost one
looks lovingly
back at this world.
Where is he going?
Is this a lotus leaf I see?

REIGEN YOSANO

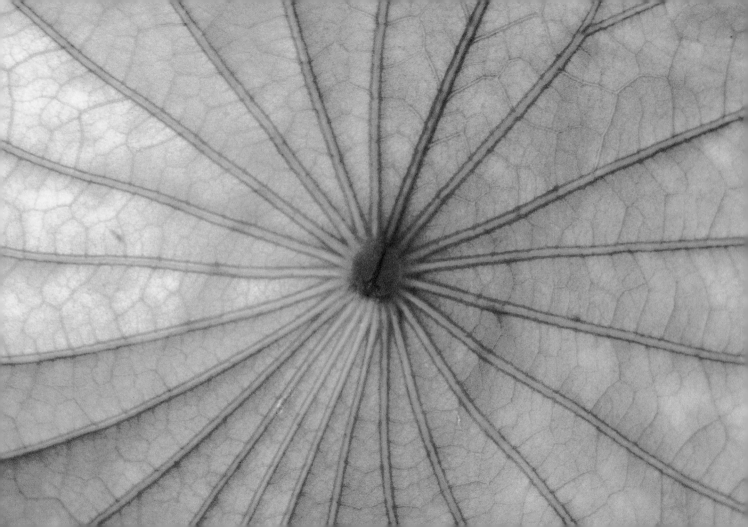

Farewell now—
let me jump onto
a lotus leaf,
so you may think
I am a frog.

RYOKAN

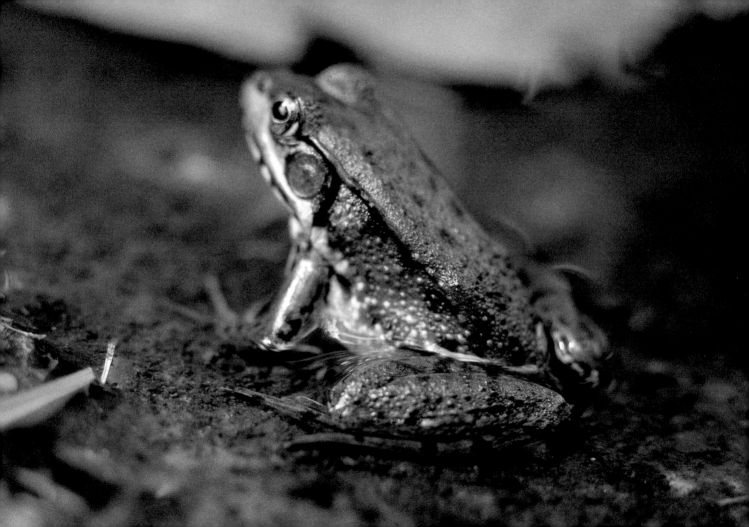

A monk asked Zen master Zhimen Guangzuo, "How is it when the lotus bud is still in the water?"

Guangzuo said, "Lotus."

A monk asked again, "How is it after it comes out of water?"

Guangzuo said, "Lotus petals."

TRADITIONAL ZEN KOAN

A monk asked Zen master Huguo Jingyuan, "How is it when the lotus bud is still in the water?"

Jingyuan said, "It depends on what you're looking for."

A monk asked again, "How is it after it comes out of water?"

Jingyuan said, "You have eyes but cannot see."

TRADITIONAL ZEN KOAN

A monk asked Zen master Langye Huijue, "How is it when the lotus bud is still in the water?"
Huijue said, "A cat wears a paper hat."
A monk asked again, "How is it after it comes out of water?"
Huijue said, "A dog puts on shoes and walks around."

TRADITITIONAL ZEN KOAN

When you are deluded, you are turned by the dharma blossom.
When you are awakened, you turn the dharma blossom.
When you leap beyond delusion and awakening, the dharma blossom turns the dharma blossom.

DOGEN

Make the form formless form,
going and returning, not anywhere else.
Make the thought thoughtless thought,
singing and dancing, the dharma voice.
How vast the sky of unobstructed concentration!
How brilliant the full moon of fourfold wisdom!
At this very moment, what can be sought?
Nirvana is immediate.
This place is the lotus land.
This body is the buddha body.

HAKUIN

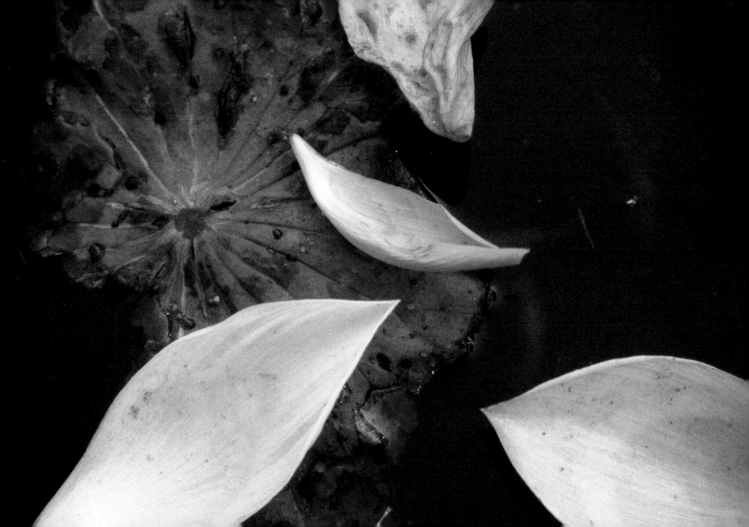

Beyond yesterday, beyond today
white lotus,
blossoming.

SUIHA WATANABE

Faraway mountains
reflected on the eyeballs
of a dragonfly.

ISSA KOBAYASHI

Life and death are of grave importance.
The blossoming of the great lotus
is complete.

SOSEKI NATSUME

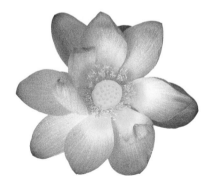

· · · Appendix: The Lotus in the World

THE LOTUS CROSSES CULTURES

SINCE ANCIENT TIMES the lotus has captured the imagination of poets and artists from Egypt and Greece, the Middle East, and South and East Asia. It has represented divinity, compassion, enlightenment, fertility, prosperity, reincarnation, paradise, and the cosmos itself. It has also been put to many practical uses: the flowers are used in dyes, perfume, and aromatic oil; the roots, stems, fruit, and seeds for food; the leaves for wrapping food; and all parts of the plant for medicine.[2] The seeds are made into beads and strung together into rosaries. The dried lotus fruit becomes the "bristle" of a calligraphy brush. The bottom of the flower is used as a wine cup. The fiber inside the stalks and leaves is made into threads for weaving. The threads made of the lotus fiber were believed in Japan to lead people to the Buddha's Pure Land.[3]

In East Asia the lotus is associated with labor. Harvesting its rootstocks in winter was traditionally the work of women, and consequently there have been romantic images of young women working in water. In China the word lotus—*lian*—has the same sound as a word that means falling in love. And also in

China, since ancient times, throwing the seeds was a maiden's gesture of erotic temptation. But above all, with its unstained beauty the lotus has symbolized pure, faithful love.

The lotus is the national flower of India and Sri Lanka, where the plant is often used to decorate weddings. By contrast it is a flower of mourning in Japan. Silver and golden paper flowers in funerals console the grieving family.

Homer's *Odyssey* mentions a land in North Africa where "lotus-eaters" forget everything and live in a happy, lazy daze.

LOTUS AS WORD AND MANTRA

In English, the word *lotus* has signified either a lotus itself or a water lily. From Egypt to Asia, where the lotus symbolism occurs, it is not limited to the lotus proper, but usually includes the water lily.

In the Sutra on Visualizing Amitayus, a Mahayana Buddhist text, five types of flowers that are said to be found in the Pure Land are listed in the ancient Indian language of Sanskrit: *padma, utpala, nilotpala, kumada,* and *pundarika.*

Padma, with its red and white flowers, is translated into Chinese as *lianhua* ("lotus") or *honglianhua* ("red lotus"). *Utpala* is translated as *shuilian,* a water lily according to the Western classification, also with red and white flowers. *Nilotpala* is *qinglianhua* in Chinese, meaning "blue lotus." *Kumada* is *dixihua,* meaning "earth-rejoicing flowers"—a water lily with red and white flowers. *Pundarika* is *bolianhua* or white lotus, which is also a water lily.[4]

The English word *lotus* comes from a Latin word of

the same spelling, which in turn comes from the Greek *lotos*. Ultimately, this Greek root may be related to the Hebrew word *lot*, meaning "myrrh."

The ancient, indigenous Japanese word for lotus is *hachisu,* meaning "honeycomb," after the shape of its seedbed. The contemporary Japanese word is *hasu,* an abbreviated form. As a Buddhist term, the lotus is called *renge,* a Japanese transliteration of the Chinese word *lianhua*. This word is most commonly heard in the mantra *Nam myoho renge kyo* ("Homage to the Sutra of Wondrous Lotus Flower").

The sacred lotuses that have grown in the Nile and its tributaries in Egypt since ancient times are, scientifically speaking, the blue-and-white-flower water lily. The yellow lotus is indigenous to eastern North America. The scientific name *lotus* indicates a totally different plant of the pea family, a *linguminosae.*

The Latin name for the lotus genus is *Nelumbo*, and the water lily *Nymphaea*. Both are freshwater perennial plants, with a rhizome buried in the mud at the shallow bottom of a river, pond, lake, or marsh. It has been commonly thought that the lotus as well as the water lily proper, or pond lily, belong to the water lily family, *Nymphaeaceae*, meaning "flowers of the water nymphs." But according to recent DNA studies, it is now believed that these two plants took separate paths of evolution. Now, the lotus is classified as *Nelumbo* genus in the independent family *Nelumbonaceae.*

Some water lilies are huge. The Victoria Regia, a fragrant variety of water lily cultivated in Great Britain from a species discovered in Guiana in 1849, can grow leaves

twelve feet in diameter and flowers fifteen inches across.

The petals of the water lily are usually thin and sword-shaped, while those of the lotus are fat and round, often with pointed tips. Both water lilies and lotuses can be white, red, pink, yellow, and blue. The leaves of the water lily are round but slightly heart- or shield-shaped, while those of the lotus are egg-shaped. What distinguishes the lotus notably from the water lily is that the former has a cone-shaped seedbed in the center of its blossom.

BLOSSOMING OF THE LOTUS

The lotus flower blossoms differently according to species, or variety, and climate. The yellow lotus takes about twenty days to blossom after the bud rises above the water. On the first day of blooming, the flower opens in early morning, stops opening at its beginning stage after a few hours, then starts to close. On the second day it begins to open again in early morning, and fully unfolds in mid-morning. It stays open for several hours, and is fully closed by night. This process repeats on the third and fourth days, when the petals gradually fade and fall away, leaving the fruit receptacle behind.[5] Afternoon lotus-viewing is not recommended.

THE LOTUS IN EGYPT AND GREECE

The lotus embodies the ancient Egyptian hope for rebirth. In the pharaohs' era Egyptians believed that Horus, the falcon-headed sun god, is born daily from a lotus flower: both Horus and the sun die at the end of each day. Osiris, father of Horus, and king of judges of the dead, wears a crown of lotus buds. These flow-

ers open in the world of rebirth. The soul of a deceased person grasps a lotus before embarking on its journey to judgment and resurrection.

One temple painting in Egypt shows Horus seated naked on a half-open lotus flower placed on a square pedestal. This image is sometimes carved into the coffin of a royal family member, or forms the capitals of temple columns.

In Hellenistic Greece the repeated pattern of stylized lotus blossoms was used in decorative friezes. Images of Eros and Psyche stand on lotus tori. In the ancient empire of Assyria, the moon god was represented as a disk with wings who was seated on lotus petals. In Persia an opened lotus was venerated as a manifestation of the sun.[6]

THE LOTUS IN THE INDIAN CREATION MYTH

The lotus also appears in ancient Indian creation myths. According to the pre-Hindu Vedic *Taittiriya Brahmana*, the god Prajapati was in the primordial waters and wondered how to create the world. Seeing a lotus leaf, he spread mud over it, and this mud-covered lotus leaf became the earth.

In another better-known account, Vishnu, one of the chief deities of Hinduism, was lying on a coiled serpent in the waters of the void when a lotus stalk grew from his navel. The lotus blossomed to reveal Brahma, another diety, who sat on the flower and created heaven, earth, and all things.

In Hindu mythology, Lakshmi, goddess of love, good fortune, and fecundity, was born from the lotus. Vishnu,

her consort, holds a lotus in one of his hands, which symbolizes his union with her. Lakshmi is known as a granter of sovereignty: in union with her a man becomes king and when she leaves he loses power. This goddess is garlanded by lotuses, surrounded by lotuses, colored like a lotus, and distinguished by her lotus-like fragrance.

THE LOTUS AS A SYMBOL OF AWAKENING

As the Indian creation myth suggests, the lotus opens the world—and it also awakens human consciousness. Growing in muddy water yet remaining unsoiled, in Buddhist thought the lotus reflects clear awareness and undefiled conduct, transcending the world of delusion. Shakyamuni Buddha, the founding teacher of Buddhism, is sometimes called "the lotus preacher." And the type of robe worn by him and all monks and nuns who have followed him is called "the lotus robe," and it is said to signify purity.

Shakyamuni Buddha lived from approximately 566 to 486 B.C.E. He taught people of diverse social status in northern India for over forty years. Soon after the Buddha's death, his senior disciples formed a council and compiled his *dharma,* or teachings. The most ancient Buddhist texts include some mystical elements about the life of the Buddha. According to the Sutra of Past and Present Causation, Lady Maya went into a garden in Lumbini in present-day Nepal, and gave birth to the *bodhisattva*—the Buddha-to-be—under a tree. He emerged from the right side of her torso, landed on a great lotus blossom, walked seven steps, and said, "Alone above and below the heavens, I am the honored one."

THE LOTUS IN EARLY BUDDHIST ICONOGRAPHY

In early times Buddhists refrained from creating images of the Buddha; his awakening or enlightenment was not to be represented through human forms. In the stone carving of the stories of the Buddha's life in Sanchi in central India, created around the first century C.E., he was represented by an empty space. By the second and third centuries, the Buddha's icons emerge in Gandhara, in the present Kashmir, and Mathura in northwest India. Gandharan sculpture shows Hellenistic influences, while the Mathura ones do not. Seated figures of the Buddha in these regions take a crossed-legged seating posture called "lotus position" (*padma asana* in Sanskrit).

In Gandhara, sculpted images of Shakyamuni Buddha, together with multiple buddhas who have emerged by means of his magical powers, are seated or standing on pedestals decorated with lotus petals. This type of pedestal, possibly following the format of divine pedestals in Hinduism, has become standard in Buddhist iconography.

Among the Gandhara and Mathura sculptures are early images of bodhisattvas holding the open lotus. These bodhisattvas are called *padma pani*, or "lotus bearers."

THE LOTUS SUTRA

It is uncertain when the Sanskrit version of Wondrous Lotus Dharma Sutra (*Saddharma Pundarika Sutra*) originated in India, but we do know that it was first translated into Chinese by Dharmaraksha in 286 C.E.

The Lotus Sutra, as it is commonly known, was retranslated by Kumarajiva in 406, and this retranslation became the standard version.

By the time the Lotus Sutra emerged, Mahayana Buddhist scriptures had become grandiose and surreal. The scale and time frame of their stories are enormous and the tales are full of poetry, parables, and mystical happenings. They elucidate the doctrines of One Vehicle—transcending differences between pre-Mahayana and Mahayana teachings—and the eternal life of Buddha. Simply holding, chanting, studying, or copying this sutra is said to be of great merit.

One might assume that in this large sutra, the lotus symbolism is explained and the image of this flower appears a number of times; but curiously, this is not the case. While celestial beings frequently celebrate the Buddha's discourses by raining down heavenly flowers,

the lotus itself is seldom mentioned. Its most prominent mention is in the story of Bodhisattva Gadgadasvara (whose name means "wondrous sound"). Praised by the Buddha for his enormous shining body, Gadgadasvara goes into a meditative state and miraculously manifests numberless lotus blossoms.

LOTUS KING

In the Lotus Sutra, Bodhisattva Avalokiteshvara (the bodhisattva of compassion, whose name means "observer of the voices of suffering in the world") transforms himself into thirty-three forms to save all beings in the world. Devotees of the bodhisattva visualize these various forms. One popular depiction is an icon with eleven heads and one thousand arms, with an eye on each hand. The Avalokiteshvara pan-

theon, which encompasses the different manifestations of this bodhisattva and related figures, is called the Lotus Family in Buddhist iconography, and as a group they represent reality itself (this is in contrast with the Vajra Family, which represents wisdom, and the Buddha Family, which encompasses reality and wisdom).

Many of the depictions of the Lotus Family show beings holding a lotus blossom, which is often closed. A closed lotus is called "a flower not yet unfolded" and it reflects the bodhisattva's vow to awaken all beings.

Rengeo-in, the Temple of the Lotus King—Avalokiteshvara—near the central station in Kyoto, Japan, is commonly known as Sanjusangen-do, or the Hall of Thirty-three Ken. (One *ken* is about ten feet. There is a huge wooden column at each ken.) It houses one thousand gilded figures of the thousand-armed standing images of Kannon, as Avalokiteshvara is popularly known in Japan, along with fierce-looking images of guardian deities, including the wind and thunder gods. This temple was built by the warrior ruler Kiyomori Taira, at the request of Emperor Goshirakawa, which was completed in 1164 in the late Heian Period (794–1192). Each of the Kannon figures, however, does not actually have one thousand physical arms (only forty). The figures were created with the belief that each arm of the bodhisattva saves beings in the twenty-five realms, including the six paths of transmigration—the worlds of celestial beings, humans, animals, hungry spirits, fighting demons, and hell. Forty multiplied by twenty-five makes one thousand. Each statue of Kannon stands on a lotus pedestal.

THE LOTUS-WOMB WORLD

The Avatamsaka Sutra was first translated into Chinese by Buddhabhadra from 419 to 420 C.E., and then by Shiksananda from 695 to 699. Its full Chinese title *Dafangguang Fu Huayan Jing* may be translated as the "Great Vast Buddha's Flower Sublimity Sutra" but it is usually known in English as the Flower Garland Sutra or the Flower Ornament Sutra. In China this sutra became the central scripture of the Huayan (Avatamsaka) School established by Fazang (643–712). In Korea it has been regarded as the most important sutra. Buddhism was introduced from Korea to Japan in the mid-sixth century, and the Kegon School, the Japanese form of the Huayan School, was established in the formative period of Buddhism in Japan.

A compound of various sutras, the Avatamsaka Sutra expounds a doctrine that the entire universe is a manifestation of Vairochana, buddha of luminosity. It presents the striking notion that the universe is enveloped in a lotus blossom, like a fetus inside its mother's womb. This universe is called the Lotus-Womb World *(padma garbha loka dhatu)*, where Vairochana is omnipresent.

THE LOTUS ENVELOPS
THE UNIVERSE

In this universe, according to the Avatamsaka Sutra, innumerable air mandalas, or wind disks, are laid atop each other. The top disk is filled with fragrant water. In its center blossoms a great lotus flower, containing an ocean of glorious blossoms. Its petals form the surrounding mountains. Its seedbed is the earth, with

countless seed pods filled with fragrant water, each containing a seed. Each seed embodies twenty worlds. The *Saha* world where humans live is the thirteenth from bottom.

There are innumerable majestic universes of Vairochana like this Lotus-Womb World. In each cosmos, every particle reflects the countless dharma worlds, and Vairochana is present in each particle.

The Todai Temple in Nara houses an enormous gilded image of Vairochana Buddha, the largest cast sculpture in the world. The temple was built at the wish of Emperor Shomu in 752 to actualize the Lotus-Womb World and facilitate the flourishing of the dharma in Japan.

CHAKRAS AS LOTUS BLOSSOMS

Tantric Hinduism and tantric Buddhism both arose about the fifth century C.E. in India. Tantrism is mystical practice encompassing yoga, rituals, and cosmology in an attempt to achieve union of microcosmic human energy and macrocosmic divine energy. Yogic meditation includes conscious breathing, visualization, and incantation.

Meditation on the chakras is essential to the practice of the Hindu tantric yoga. *Chakra*, meaning "wheel" or "circle" in Sanskrit, is a power-center of the body of subtle lifeforces, which is made up of various elements including consciousness.

Commonly there are six chakras. The chakras align one's spine from its base to above the eyebrows. Each chakra is represented by a lotus flower, of which the

color and the number of petals vary. In addition to these six, there is a chakra at the crown of the head with a thousand-petaled lotus. In Buddhist tantric yoga, four chakras are said to be situated, one each, around the navel, heart, throat, and head.

Kundalini, meaning "coil" in Sanskrit, is regarded as a female serpent—a goddess—deriving from the Vishnu creation myth. It is regarded as the source of energy, present both in the cosmos and in human beings. Usually Kundalini is asleep in the lowest chakra. When awakened by a yoga practitioner's mind-body practice, the energy goes upward, opening the chakra flowers, energizing each complex, and finally reaching the highest subtle center, opening the thousand-petaled lotus and completing the union with the supreme god.

THE LOTUS FILLS THE MANDALAS

Deities dwell in each chakra, arrayed in the form of a mandala. *Mandala* means a "circle," "disk," or "wheel" in Sanskrit. A tantric mandala represents the pantheon of gods and goddesses worshipped in rituals.

In early Hindu mandalas, scores of equal-size squares were laid out in a complex, symmetric form. Then the design became more elaborate, using margins, corners, and geometric lotus-shaped seats of deities, while the number of squares was reduced. Such a mandala is ceremonially drawn in vermilion or red on the purified temple floor.[7]

THE LOTUS-SEATS IN MANDALAS

There are many types of mandalas in esoteric Buddhism, but perhaps the most notable examples are the Womb-World Mandala, based on the Mahavairochana Sutra, and the Diamond-World Mandala, based on the Vajra Peak Sutra. These mandalas were central to the fire rituals of the Shingon School, one of the most influential schools in Japan's Heian Period.

In the Womb-World Mandala, 414 celestial beings are laid out in twelve rectangular sections. The central court is arranged in the shape of an open lotus—a circle surrounded by double petals in the shape of half circles. Seated in a large circle is Mahavairochana, the tantric Buddhist form of Vairochana. The four buddhas of the four directions, surrounding the central buddha, are placed in the direction of a sun dial, forming an inner circle of crescent petals. The next four deities are put in a spiral order, forming the outer circle of petals. This mandala represents Mahavairochana's all-inclusive wisdom.[8]

SOUND OF THE LOTUS

Padmasambhava, whose name means "Lotus-born," is also called the Second Buddha in Tibet. This revered tantric sage, exorcist, and magician is believed to have been born from a lotus in Dhanakosha Lake in western India. Legend says that he introduced Vajrayana Buddhism to Tibet around the eighth century.

The most widely recited mantra in Tibet's Vajrayana Buddhism is the six-syllable Sanskrit phrase, *Om mani padme hum*. It is a mantra dedicated to the bodhisattva Avalokiteshvara (Chenrezig in Tibetan),

the embodiment of compassion. It is believed that this bodhisattva was the founder of the first Tibetan dynasty, Songtsen Gampo, in the seventh century, hence he is guardian deity of the nation.

Om is an ancient Vedic syllable, regarded as the primary sacred sound. A contraction of the sounds "a," "u," and "m," this untranslatable syllable often comes at the beginning of a mantra or a prayer as invocation of a deity. *Mani* is a celestial wish-granting jewel. *Padme* is the feminine vocative form of *padma*, meaning "lotus." *Hum* is another untranslatable syllable, which concludes the prayer. One interpretation of this mantra is: "Oh, the divine jewel in the lotus. I am all yours." One deepens identification with the jewel, the lotus, the bodhisattva, and compassion through innumerable incantations of these sounds.

This mantra is carved on stones scattered by roads across Tibet's remote highlands. It is printed on countless prayer flags and colorful banners, which flap in the winds through all seasons. "Om mani padme hum" is inscribed on walls—sometimes miles long—and on rooftops. It is written on paper and contained in prayer wheels, invoking the presence of Avalokiteshvara.

When devotees are at work or in motion, fingers advance their rosaries one bead after another, "Om mani padme hum" is murmured on each breath. Pilgrims spend months doing prostrations—laying their bodies out completely at every step of the road—while reciting this mantra.

LOTUS IN PARADISE

Worshipped by millions of devotees, Amitabha Buddha has attained a unique monotheistic status in Buddhism. *Amitabha* means "immeasurable light." Also known as Amitayus or "immeasurable lifespan," he is not mentioned in the Theravada canon, thus belonging wholly to the Mahayana tradition.

Amitabha Buddha presides over the western part of the universe, the Pure Land. Belief in Amitabha started in India probably around the first century C.E. The Innumerable Lifespan Sutra was first translated into Chinese by Sanghavarman around 252.

The Sutra on Visualizing Amitayus, translated into Chinese by Kumarajiva in 402, describes the Pure Land as a place where splendid lotus flowers as large as wheels, radiating blue, yellow, and red light bloom in water. (See page 82)

When a person with sincere faith in Amitabha dies, the Buddha himself places that person on a lotus leaf, upon which that person will be transported to Amitabha's Pure Land. There, the person is reborn from the bud of a lotus flower and achieves buddhahood.

THE LOTUS IN ZEN AND ZEN KOANS

Zen is the Japanese transliteration of the Chinese word *chan*, which is the abbreviation of *channa*, again the Chinese transliteration of the Sanskrit word *dhyana*, meaning "meditation" or "absorption."

Bodhidharma, a semi-mythical Indian monk of the sixth century, is regarded as founder of the Chan school in China. The practice of Chan or Zen meditation is traditionally in the lotus posture, in which each foot rests upon the opposite thigh. A highly formalized daily schedule of monastic life, including labor and the formal taking of meals, supports the monastic meditation practice. Instead of depending on scriptures, the immediate awakening that transcends dualistic thinking, theory, and convention, is emphasized. Awakening must be authentic to each person at each moment.

In order to facilitate this teaching, eccentric dialogues of earlier Zen masters are studied as model cases. Such a story, called *gongan* in Chinese and *koan* in Japanese, means "public case." Some of the most frequently used koans include: "Why did Bodhidharma come from India?" or "Does a dog have buddha nature?" Zen practitioners are given such questions by their masters in order to investigate the meaning of universal awakening.

Masters and students respond to the same questions, and earlier masters' responses are used as materials for study. Masters, as well as students, often express themselves in unconventional ways: enigmatic or vulgar statements, nonsequiturs, repetitions, tautologies, silence, yelling, or eccentric behavior, even beating. Shocking statements like, "When you meet the Buddha, kill the Buddha," or upside-down language like, "A bowl rolls inside the pearl," are revered as expressions of awakening.

One set of frequently asked questions is: "How is it when the lotus bud is still in the water?" and "How is it after it comes out of the water?" (See page 106) These

questions deal with the basic Buddhist concept that all people have buddha nature that does not emerge until it is actualized.

A Japanese book titled *Zemmon Koan Taisei (Collection of Koans in the Zen School)* by Kaiho Otobe, published in 1919, includes over 5,500 koans. Among them, thirty-two cases deal with these particular questions on the lotus. Each set of answers is different in its tone and flavor, reflecting the master's style of teaching. These examples demonstrate the importance of a free and dynamic state of mind, emphasizing the fresh, spontaneous, and unexpected miracle of each moment. Thus, beyond its natural beauty and elaborate symbolism, the lotus is also treated as an unadorned pointer to awakening.

THE LOTUS
IN THE CEREMONIAL MEAL

Cooking and having meals, just as all other activities in Zen monasteries, are highly ceremonial matters. Dogen, a thirteenth-century Japanese monk who brought Zen teaching from China to Japan, wrote in detail on how to work in the kitchen and how to serve in the meditation hall. We do not have any account of his instruction on having meals, but those who participate in monastic activity or formal meditation retreats, even in the Western world, still experience the very stylized forms of bowing, chanting, untying the wrapping cloth, spreading it, setting the utensils, receiving food, and eating. The eating bowls, consisting of three different-sized ones, traditionally lacquer, are called *oryoki*, meaning "utensils that are suited for the size (of

food that is taken)." There are chopsticks, a wooden spoon, a cleaning stick on a cloth wrapped around on its tip, a drying cloth, and the cloth that covers the lap.

At the end of the meal, hot water is served to wash the utensils, one by one according to the set order. The servers bring a large container to collect dirty water that is ceremonially dedicated as nectar to hungry beings.

At the end of the meal, the lead chanter chants: "May we exist in muddy water with purity like a lotus. Thus we bow to Buddha." The utensils are then put together and wrapped with a cloth. One end of the cloth on top of the knot is left slightly long and shaped like a lotus petal.

THE LOTUS LAND

While Dogen is regarded as founder of the Soto School, Hakuin (1685–1768) is considered restorer of the other main school of Zen in Japan—the Rinzai School. He was a great painter and calligrapher, but above all a strict and outstanding Zen teacher. The "sound of one hand clapping" is the koan he created to help his students break through their habits of dualistic thinking.

"In Praise of Zazen," a verse written by Hakuin, is still recited daily in Rinzai monasteries. In the last part of the poem, he says, "Nirvana is immediate. This place is the lotus land." (See page 108) These lines point to centuries of Zen tradition focused on an authentic experience of "here and now," moment by moment.

THE LOTUS OF THIS MOMENT

Soseki Natsume (1867–1916) was Japan's pioneering scholar of English literature, as well as an outstanding poet and novelist. As you can see in one of his poems, he was influenced by Zen. (See page 113) The line "Life and death are of grave importance" is expressed in only five syllables—*shoji jidai*. It is a phrase usually found on a temple's wooden board or *han*, which is struck with a wooden mallet, signalling the start and end of Zen meditation. The next line of this poem, "The blossoming of the great lotus is complete," crystallizes one moment of Soseki's experience. And yet one may realize the completion of the lotus blossoming at any moment.

Glossary of Proper Names

Names of persons, deities, and texts mentioned in this book are briefly explained here. Macrons are used in this glossary but not in the main text. Sanskrit spellings are simplified. Chinese words are represented by the Pinyin system. The dates are C.E. (A.D.) unless otherwise specified.

Amitābha: The Buddha of "immeasurable light." Also called Amitāyus ("infinite life span"). The lord of the Pure Land in the western part of the universe. The central deity in Pure Land Buddhism.

Amitāyus Sūtra: Originally titled *Sukhavati Vyūha*, and known as the Amitāyus Short Sūtra, this sūtra was translated by Kumārajāva from Sanskrit into Chinese in 402. One of the three major sūtras of the Pure Land schools.

Avalokiteshvara: Bodhisattva of compassion, sometimes described as having one thousand arms and eyes. The Chinese name Guanyin and the Japanese name Kannon mean "one who hears the cries of the world." "Bodhisattva" means "one who helps others to awaken."

Avatamsaka Sūtra: An extensive Mahayāna scripture. First translated from Sanskrit into Chinese by Buddhabhadra in 419–420. Became the base for the Chinese Huayan School and the Japanese Kegon School. It expounds the doctrine that the whole world is a manifestation of Vairochana Buddha, who is omnipresent in every particle.

Bodhidharma: Ca. sixth century. Brought the Zen teaching from India to China. Taught at the Shaolin Temple, Mt.

Song, Henan Province. Regarded as the First Chinese Ancestor of the Zen School.

Bo Yuyi: 771–846, China. A poet of the Tang Dynasty. Also known as Yuetian. Widely acclaimed for his exquisite but comprehensible style.

Brahmā: Creator in Hindu mythology. The deified Brahman, the original source of existence.

Dhammapada: One of the best known scriptures of the Pāli canon, containing some of the earliest known teachings of Shākyamuni Buddha. Consists of 423 verses. Its title means "Words of Truth."

Dōgen: 1200–1253, Japan. A reformer of Buddhism in the Kamakura Period. Brought Zen teaching from China and taught single practice of Zen meditation. Founded the Eihei Monastery, Echizen Province, and is regarded as founder of the Sōtō School, one of the two major schools of Zen in Japan. Author of *Shōbōgenzō* (Treasury of the True Dharma Eye).

Ekotottara Āgama: A Pāli scripture. Subjects are arranged numerically.

Enkū: 1633–1695, Japan. A wandering monk and mountaineering ascetic of the early Edo Period. He made more than 100,000 wooden carvings of Buddha images. His sculpture is known for its rough and decisive quality. He wrote a great number of poems dedicated to deities he enshrined.

Fan Chengdai: 1126–1193, China. Song Dynasty. Also known as Shifu.

Fujiwara, Michitsuna's mother: Tenth-century, Japan. A poet of the Heian Period. A wife of the regent Kaneie Fujiwara. Author of the journal, *Kagerō Nikki* (The Gossamer Years), which covers the period 954–974. Unfortunately, her personal name is lost to history.

Fujiwara, Sanekata: d. 998, Japan. A poet of the Heian Period.

Fujiwara, Shigekata: Thirteenth century, Japan. A poet of the Kamakura Period. Participated in a waka competition in 1263.

Gadgadasvara: The bodhisattva described in the Gadgadasvara ("wondrous sound") chapter (the twenty-fourth chapter) of the Lotus Sūtra as one who visited the Sahā World, where humans live, from the luminous paradise and offered immeasurable-scaled music and flowers to the Buddha.

Gimei: 1696–1748, Japan. A haiku poet of the Edo Period.

Goshirakawa, Emperor: 1127–1192, Japan. On throne 1155–1158. He was influential in politics as former emperor for over thirty years in the late Heian Period.

Hakuin: 1685–1768, Japan. A monk regarded as the reviver of the Rinzai (Linji) School, one of the two major schools of Zen Buddhism in Japan. Known also for his powerful calligraphy, painting, and poetry.

Henjō: 816–890, Japan. A waka poet of the early Heian Period. A sōjō (bishop) of the Tendai School Buddhism.

Hōnen: 1133–1212, Japan. Taught the single practice of chanting Amitābha Buddha's name. Founder of the Pure Land School in Japan. An early reformer of Buddhism in the Kamakura Period.

Horus: The sun god in Egyptian myth. Son of the creator king Osiris and his sister-wife Isis. Horus is regarded as king of the living, while Osiris is regarded as king of the dead.

Huang Tingjian: 1045–1105, China. A poet and calligrapher of the Song Dynasty. Also known as Shangu.

Huangfu Song: Ninth century, China. A poet of the Tang Dynasty. Son of the poet Hungfu Shi (777?–830?).

Huguo Jingyuan: 1094–1146, China. Song Dynasty. A Zen monk of the Linji School. Taught at the Huguo Monastery, Zhejiang Province.

Huiguan: 368–438?, China. A Buddhist monk and scholar of the Jin Dynasty. Author of the *Essential Introduction to the Lotus School.*

Huineng: 638–713, China. Tang Dynasty. The Sixth Chinese Ancestor of the Zen School. He is regarded as founder of the Southern School of Zen. Some of his dharma discourses are included in the Sixth Ancestor's Platform Sūtra.

Indra's Net Sūtra: One part of the sixty-one-part sūtra called the *Bodhisattva's Mind Ground Precepts Expounded by Vairochana Buddha.* Only this part of the sūtra was translated from Sanskrit into Chinese and revered in East Asia as the basic text for the bodhisattva precepts in Mahāyāna.

Innumerable Life-span Sūtra: Titled in Sanskrit, *Sukhavati Vyūha,* this sūtra is also called the Amitāyus Long Sūtra. One of the three major scriptures of the Pure Land Schools. First translated into Chinese by Sanghavarman around 252.

Juntoku, Former Emperor: 1197–1242, Japan. Kamakura Period. On throne 1210–1221. Known for his waka poems.

Kankoku Anthology: A Kamakura Period collection of waka poems by different poets, edited 1181–1217. Editor unknown.

Kobayashi, Issa: 1763–1824, Japan. A haiku poet of the late Edo Period. Known for his colloquial and humorous style. Author of poetic essays including *My Spring.*

Kūkai: 774–835, Japan. Great Master Kōbō. A Buddhist monk in the early Heian Period. He brought esoteric (Vajrayāna) Buddhist teaching from China to Japan and founded the Shingon (Mantra) School, which became one of the most important Buddhist schools in the Heian Period. He was known for his poetry and essays and is regarded as the "sage of calligraphy" in Japan.

Kūya: 903–972, Japan. A Buddhist monk of the mid-Heian Period. He traveled all over Japan and helped build bridges, waterways, and shrines. He taught recitation practice of the name of Amitābha Buddha and was regarded as a street sage.

Lakshmi: Goddess of love, fecundity, and prosperity in Hinduism. As wife of Vishnu, she actualizes his wishes. Associated with the lotus in every possible way.

Langye Huijue: Ca. eleventh century, China. Song Dynasty. A monk of the Linji School of Zen. Taught at Mt. Langye, Anhui Province.

Li Bo (also written as *Li Po*): 701–762, China. A poet of the Tang Dynasty. Celebrated for his spontaneous and brilliant style of poetry derived from his wild life.

Lotus Sūtra: Called in Sanskrit, *Saddharma Pundarika Sūtra* (the Wondrous Lotus Dharma Sūtra). An extensive Mahāyāna Buddhist scripture, often called *king of all sūtras.* It includes the doctrines of the eternal life of the Buddha and all Buddhist teachings as One Vehicle. First translated into Chinese by Dharmaraksha in 286.

Mahā Prajñā Pāramitā Sūtra: A comprehensive collection of scriptures on prajñā pāramitā—realizing wisdom beyond wisdom. Some parts are the earliest known form of the Mahāyāna scriptures, emerged in the first century, B.C.E. The 600-fascicle version was translated from Sanskrit into Chinese by Xuanzhang in 663.

Mahāvairochana: The Buddha, the "great illuminator." The central deity of esoteric Buddhism.

Mahāvairochana Sūtra: One of the major sūtras of esoteric Buddhism. Expounds the doctrine of the womb storehouse dharma.

Majjhima Nikāya: A "medium-size" sūtra in the Pāli canon.

Masaoka, Shiki: 1867–1903, Japan. A modern reformer in haiku poetry, he emphasized *shasei,* or realistic portrayal of nature.

Matsuo, Bashō: 1644–1694, Japan. The founder of haiku poetry, who lived in the early Edo Period. Known for his profound, meditative style. A lay practitioner of Zen Buddhism. Author of poetic essays including *A Narrow Road in the North.*

Minamoto, Toshiyori: d. 1125, Japan. A courtier and waka poet of the late Heian Period. He was known for expression of unadorned feeling and everyday life.

Murakami, Kijō: 1870–1938, Japan. A haiku poet of the Meiji Period. A colleague of Shiki Masaoka.

Natsume, Sōseki: 1867–1916, Japan. A poet and novelist of the Meiji Period. Also a pioneer of English literature study in Japan.

Nichiren: 1222–1282, Japan. One of the reformers of Buddhism in the Kamakura Period. Taught a single practice of chanting the title of the Lotus Sūtra. Founder of the Nichiren School of Buddhism.

Ōga, Ichirō: 1884–1965, Japan. A biologist, PhD. Dedicated his life to the study of the lotus.

Padmasambhava: Ca. eighth century. Regarded as the sage who brought tantric Buddhism from India to Tibet. Known also as a yoga practitioner, magician, and exorcist.

Past and Present Causation Sūtra: A scriptural biography of Shākyamuni Buddha. Only existent in Chinese.

Prajāpati: Father of gods, lords, or creatures, worshipped in Vedic sacrificial rites.

Ryōkan: 1757–1831, Japan. A Zen monk, poet, and calligrapher of the late Edo Period. Living in a small hut in a village and often playing with children, he wrote Chinese-style and waka poems. His poems reflect much meditative and compassionate wit.

Sei-shōnagon: Ca. tenth-eleventh centuries, Japan. A poet and essayist of the mid-Heian Period. "Shonagon" is her title as a court lady. Known for her essay *Pillow Book.*

Shākyamuni Buddha: Ca. sixth-fifth centuries B.C.E. Prince Siddhārtha of the Shākya Clan, who taught in Northern India. The founding teacher of Buddhism. Also called Gautama Buddha. His honorary titles include Tathāgata and the World-honored One.

Shinran: 1173–1263. A reformer of Buddhism in the Kamakura Period. A disciple of Hōnen, he taught the single practice of chanting Amitābha Buddha's name and established the Pure Land True (Jōdoshin) School.

Shōmu, Emperor: 701–756, Japan. On throne 724–749. A great supporter of Buddhism. Together with his empress Kōmyō, he built a number of state-established provincial temples, as well as the Tōdai Temple in Nara.

Shōtetsu: 1381–1459. A monk poet of the Muromachi Period. Author of the poetics, *Shotetsu Tales.*

Su Shi: 1036–1101, China. A poet and essayist of the Song Dynasty. Also known for his painting. A practitioner of Zen, he had a lay Buddhist name, Dongpo.

Taira, Kiyomori: 1118–1181, Japan. Heian Period. A warrior who defeated the rivaling Minamoto Clan, rose to the highest status in court, and ruled Japan.

Taittiriya Brāhmana: A Vedic text in ancient India.

Takai, Kitō: 1741–?1789, Japan. A haiku poet of the late Edo Period. A student of Buson Yosa.

Treatise on Great Wisdom: Kumarajāva's condensed Chinese translation from Sanskrit of Nāgarjūna's commentary on the Mahā Prajñā Paramitā Sūtra. Traditionally regarded as an essential text for the study of Māhayāna Buddhist doctrine.

Vairochana: The Buddha, the "luminous one," symbolizing the boundless wisdom of Shākyamuni Buddha. The central deity of the cosmos in the Avatamsaka Sūtra.

Vajra Peak Sūtra: One of the major sūtras of Esoteric Buddhism. Its title suggests the highest of all scriptures. First translated from Sanskrit into Chinese by Amoghavajra (705–774).

Vishnu: A supreme deity in Hinduism, eternal and omnipre-sent. Commonly depicted as a four-armed, dark blue young man.

Visualizing Amitāyus Sūtra: One of the three major scriptures of the Pure Land schools. Translated from Sanskrit into Chinese by Kālayashas (383–442).

Wang Changling: 698–757, China. A poet of the Tang dynasty.

Wang Wei: 699–759, China. A poet and painter of the mid-Tang Dynasty. His poetic style is serene and expansive. Regarded as the founder of the Southern School of painting.

Wang Youceng: Eighteenth century, China. A poet of the Qing Dynasty. He passed an examination for government officials in 1754.

Watanabe, Suiha: 1882–1946, Japan. A haiku poet of the modern time.

Wei Yizun: 1629–1709, China. A poet of the Qing Dynasty.

Wenxuan Anthology: Compiled by Jitong (501–531) of the Liang Dynasty. A large collection of selected Chinese poems from ancient times up to his lifetime.

Wu, Emperor: 464–549, China. The founding emperor of the southern kingdom of Liang. On throne 503–549. Regarded as one who had dialogue with Bodhidharma, soon after his arrival from India.

Yang Wanli: 1124–1206, China. A poet and official scholar of the Song Dynasty.

Yosa, Buson: 1716–1783, Japan. A painter and haiku poet of the mid-Edo Period. As one of the representative painters of literary-style, he was also well versed in Chinese-style poems.

Yosano, Akiko: 1878–1942, Japan. A pioneer in modern waka, she was renowned for her sensuous, bold, and fresh poetic style.

Yosano, Reigen: 1823–1898, Japan. A poet and Pure Land Buddhist priest of the Edo to Meiji Periods. Father of the poet Tekkan, Akiko Yosano's husband.

Zhimen Guangzuo: Ca. tenth-eleventh centuries, China. Song Dynasty. A Zen monk of the Yunmen School. Taught at the Zhimen Monastery, Hubei, China.

1. *Life,* November 14, 1952.

2. The medicinal use of the lotus is listed in *Chinese Herbal Medicine: Materia Medica,* compiled and translated by Dan Bensky and Andrew Gamble with Ted Kaptchuk (Seattle: Eastland Press, 1986).

3. Legend has it that a mandala painting of the Taimaji Temple, Yamato Province, was woven by a princess with lotus threads.

4. *Mochizuki Bukkyo Daijiten* (Mochizuki's Great Encyclopedia of Buddhism), Zenryu Tsukamoto, ed. (Tokyo: Sekai Seiten Kanko Kyokai, 1931–36), 5036.

5. *Hanahasu no keitai oyobi shusei* (The shape and habit of the flowering lotus), by Fumio Kitamura and Yuji Sakamoto in *Hasu no Bunkashi* (Cultural History of the Lotus) (Tokyo: Kado Shobo, 1974), 46–55.

6. In regard to the lotus symbolism in the ancient Near East, excellent descriptions are found in *The Green World: An Introduction to Plants and People,* by Richard M. Klein (New York: Harper, 1979), 143–146.

7. There is an informative discussion of this subject in the entry on "Mandalas" by E. Dale Saunders in *The Encyclopedia of Religion,* Charles J. Adams, et al, ed. (New York: Macmillan Publishing Company, 1987).

8. Ibid.

· · · *Acknowledgments*

ALLAN BAILLIE SPENT YEARS traveling and taking photographs of the lotus. He also collected extensive materials on botanical and mythological studies of the plant, as well as a great number of translated poems on the lotus. I was very impressed with his photography and research when he showed them to me in New York City in 1998, and offered my help in whatever way I could.

Then, in 2003, at the suggestion of Josh Bartok, editor at Wisdom Publications, Allan asked me to work on the textual part of this book and handed over all his research materials. I did additional research and completed the text in 2004. Thus, much of the information in the text is due in part to Allan's initial studies and his generosity.

Allan and I would like to thank Josh Bartok for his support and guidance in the entire process of creating of this book. My appreciation goes to Abby Young, Linda Hess, Karuna Tanahashi, Alan Senauke, and Minette Mangahas for their valuable editorial suggestions. During my research on the Chinese medical use of the lotus I consulted with Joseph Carter. Tim Hogan of the herbarium at University of Colorado, Boulder, was kind enough to go through my manuscript and

offer valuable suggestions. We would like also to thank Meridel Rubinstein.

Kazuaki Tanahashi

THANKS ARE DUE TO KAZ TANAHASHI for his wonderful text. And I would like to thank Sara Jane Freyman for believing in this project years before it was in print. Also, Toinette Lippe for wanting this book to be printed. Helen Tworkov helped along the way by publishing an early version in *Tricycle* magazine. Many thanks to the poet Suzanne Ostro for her contributions. I want Iris Stewart to know that I owe much to her putting up with so many stops and starts with this book, and with my struggle to know what direction to take along the long road to completion. Other people who helped with support of one kind or another are: Lora Zorian, Matt Kutolowski, Arnold Skolnick, Laura Kaufman, Berkley McKeever, and John Ankele. These photographs would not exist without the many gardens that have had such beautiful lotuses to view and put on film. The result of being around the lotus is impossible to describe, except to say that it has been a truly inspiring spiritual experience.

Allan Baille

··· About the Authors

ALLAN BAILLIE has been photographing lotuses in nurseries, gardens, and at monasteries for many years. In working on this project he ate lotus roots in New York's Chinatown; wore a hat fashioned from a lotus leaf; spent a summer day on a lotus lake in a rowboat; went wading through lotuses; and once at a lotus farm came upon a Vietnamese monk from Texas on his yearly pilgrimage to stroll among the lotus. Ironically, in the early nineties Chagdud Tuklu Rimpoche gave Allan the dharma name Peme, which translates to "lotus." Baillie's work has appeared in the *Shambhala Sun,* *Tricycle* magazine, and on the cover of *The Beginner's Guide to Zen Buddhism.* His prints have been shown in galleries and museums around the country. To view more fine art samples look at www.art-exchange.com.

KAZUAKI TANAHASHI is a painter, calligrapher, writer, and peace worker, originally from Japan. His publications include *Brush Mind, Penetration Laughter: Hakuin's Zen and Art,* and *Moon in a Dewdrop: Writings of Zen Master Dogen.* More of his work can be seen online at www.brushmind.net.